The Magical World of Twigshire

A Feel Good Book for All Ages

Vol 4

The Peculiar People of

Pondering Pond

by Judi Light

"Poom" ™

Light Touch Art™
Venice, FL

Copyright @2018 by Judi Light

ISBN 978-0-9887433-6-6

Library of Congress Control Number: 201295211

Text scheme designed by Judi Light & Eric Barnes

This book was electronically typeset in Comic Sans MS font. Cover and title page are in Zapfino. Back cover text is in Helvetica Neue.

Published by Light Touch Art™, Venice, Florida, USA

Giclée prints scanned and printed by Aaron Blackhall of Blue Line, Inc, Sarasota, FL.

DEDICATION

This book, "The Peculiar People of Pondering Pond" is dedicated To all of the Peculiar People of Planet Earth.

If it weren't for all of YOU, I wouldn't be inspired to create anything at all.

So thanks for showing up, for breathing and carrying on in your wonderfully unique ways.

With such a plethora of personalities, the inspiration is never ending.

Poom, myself, Twigshire's Dodat Manager, and all involved in this process, thank you ALL for your support – past, present and future.

Enjoy your time insidewe're waiting for you.

Love,

Judi and the Twighire Gang.

What's Twigshire and Who is Poom?

I am Poom - This is Me....(it's actually quite a flattering shot of me don't you think?)

I am the Administrative Assistant to Judi (she henceforth is referred to as "The Boss".)

Many, many people have written to or called The Boss asking about me, Twigshire and where the different characters come from. Judi asked that I come out from the back office, meet everyone formally and give you a bit of a tour of the place, including a few tidbits about some of the most favorite of the Twigshire characters.

I won't take up much of your time, I promise. Everyone inside is so excited for you to pop in and meet them, so I'll make it quick.

I was discovered about 6 years ago when Judi began this adventure of recording the goings on in Twigshire and surrounding areas, (such as Blue Bottom Bay and Pondering Pond) and capturing the antics of the many diverse inhabitants of this bustling and majickal Shire.

As she has related to me, she quite accidentally stumbled onto Twigshire one cloudy, murky day, whilst fumbling around looking for something to make her

feel better. We'd been waving at her forever it seemed, trying to get her attention...but she never looked up to see us until... until... well until she did. Which was the perfect time!

First, she bumped into Yella Umbrella Fella. (Book #1) He was having a chat in the rain with one of the locals and he quite entranced The Boss. And that was that... she never left. Lucky for us. If she had decided we weren't her sort, nobody would ever have come to see us from your side of the Pond . Now we feel so much better off knowing you all – even though my work load has quadrillioned!

Over the last 5 years (in over-the-Pond years, barely a sigh in our neck of the woods), The Boss has met, interviewed and painted the portraits of lots of Twigshire personalities. They actually stand in line waiting for their turn!

She has traveled many a snork (miles to you), discovering some whimsically fabulous spots where she actually ended up having some grand vacations. Blue Bottom Bay is one such place (book #3) Mushy Bottoms another (Book #2) - we almost lost her there I'll tell you---ALWAYS let someone know if you are going to go and visit the shrooms in Mushy Bottoms.

I could go on.. but I know you want to get on with it and visit the Peculiar People of Pondering Pond, all of whom are quite eager to welcome you in.

Try some of the special Mulberry Tea and Mushroom Fluffernutter scones - delish!

Feel free to drop me or The Boss a line, as we always welcome your questions and comments. (http://LightTouchArt.com)

FAMILY TREE

We have all heard about "Family Trees", those charts that show us who was married to our cousin and who was our great, great great grandmother hundreds of years ago. They sometimes look like this:

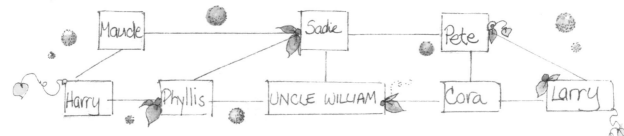

The purpose of these "Family Trees" is so we can sort out and understand where our funny toes or long ears come from (was it Uncle William or Great Auntie Sadie?)

In Twigshire, however, there is only one Family Tree. Part of it looks like this >

and includes absolutely everyone in Twigshire...EVERYONE!!!

Two legged, three legged, 12 arms, fins, noses, feathers or tails - doesn't matter. This tends to keep things simple and anyone can come up for a cup of mulberry tea, hang out, read a book or have a chat.

I mean what it all boils down to is that we are all just one big family anyway, aren't we?

The door's open, come on up - the kettle is always on and the flufferbutter mushroom scones are divine!

We're ALL family here - yes, you too!

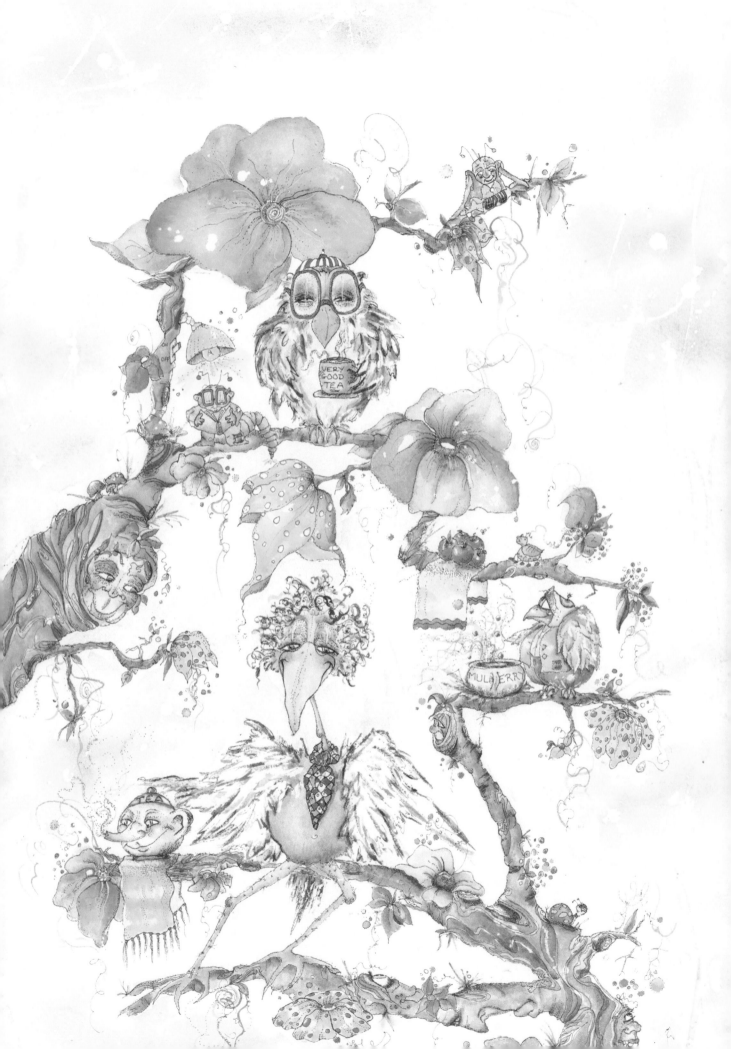

I LOVE MY SHOES

It seems that most women love their shoes. We just do. From flip-flops, to boots, high heels, platforms, sandals of all types, slippers, and on and on.

Show us a shoe sale and we'll be camping out on the store doorstep the night before, waiting for the doors to open.

I think it's genetic.

It's the same for the ladies of Pondering Pond...it doesn't seem to matter one bit whether it's Twigshire, or NY City; we're all the same.

Some people love cake and ice cream with custard,

While others would beg for pastrami and mustard.

My good friend loves music, especially the Blues,

But me, all I want is a houseful of shoes!

They can be leather or wood, or canvas or rubber,

With bows, buckles or buttons, or made from whale blubber.

I don't care!

If they fit on my feet, make a statement, look classy,

If they're just a bit big, or too tight, I'll feel sassy.

I just LOVE my shoes!

Others may choose to go out to dine

Or watch 50 movies, that's all well and fine.

Show me a shoe sale, or shoes at full price,

I'll find several pairs which I'll buy in a trice!

Don't shake your head like my mind's filled with glue,

I'm happy when shod well.

I just LOVE my shoes!

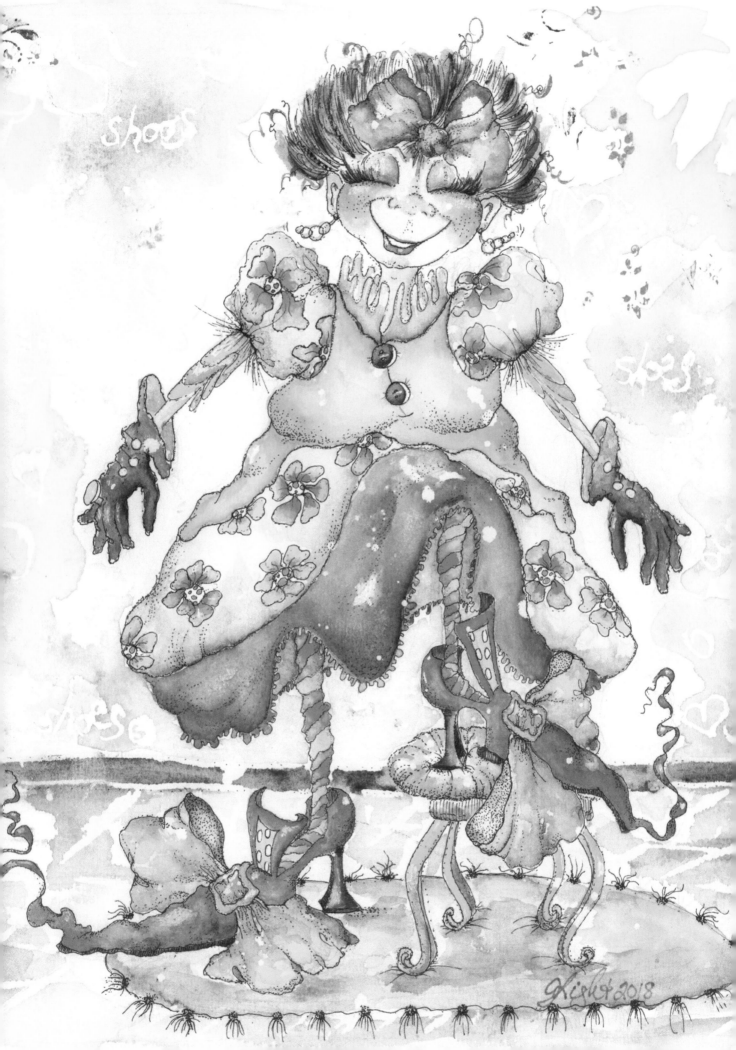

SHINE ON!

What's the best thing about being YOURSELF?

Well, there's nobody else like you, I know that indeed;

Just like all the animals, the flowers grown from a seed,

It's all thought out beforehand - yep it's true.

From the twinkle in those eyes, from the color of that hair,

To the kindness of that heart....

There's just one YOU!

So shine on and show your majick,

Shine on, show you're the one,

Shine on, go make a difference

And be that glowing sun.

Shine on!

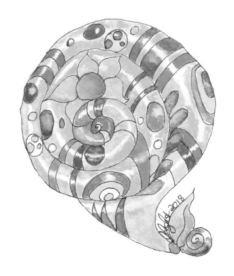

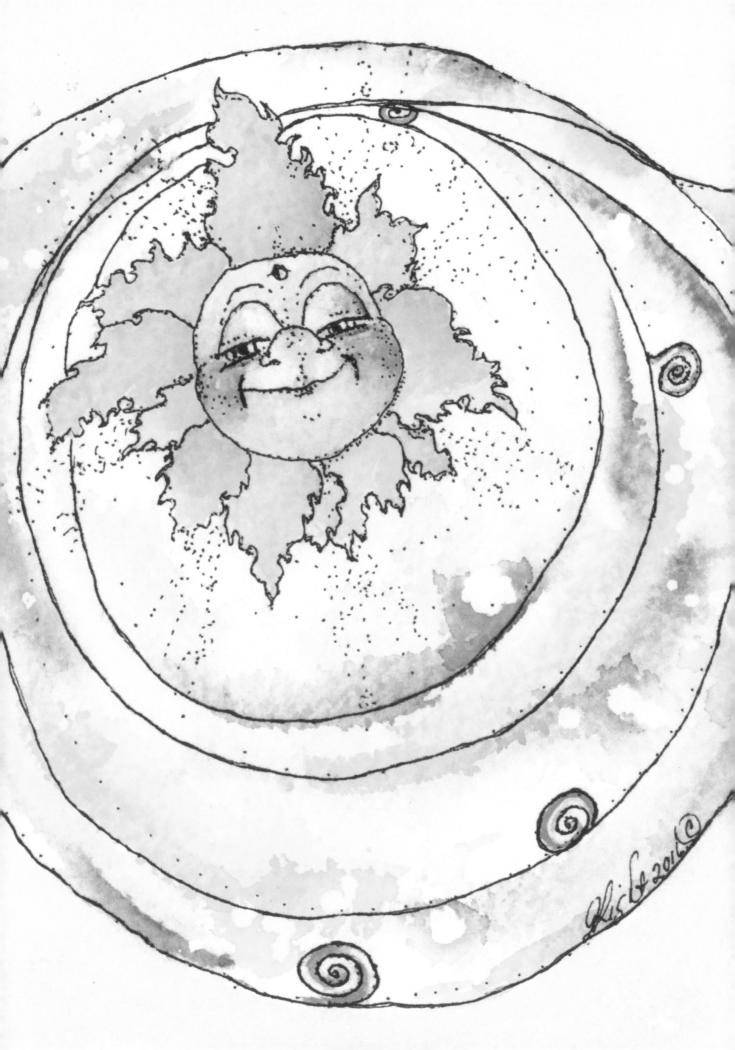

MAX, THE TUSH
(Twigshire's Ultimate Super Hero – TUSH)

Meet Max.

By day he can be found at the very popular Dumplings are Delish Bakery in downtown Twigshire. (If you have never tried their pine cone and marigold seasoned dumplings in a dish of apple and berry compote, you really need to go try it out. It's yummy!)

To the visitor to Twigshire and surrounding areas, Max seems like just a jolly, normal fellow. He's polite, shy, tending toward a bit of chubbiness (he is also the dumpling taste tester, so it's easy to understand that he might have gained a bit due to work related obligations) and he's basically nice.

But the Twigshire locals know differently: He's far more than just a dumpling taste tester!

Everyone needs a hero, to save the day, to be strong.

Everyone wants to know someone

To fix nasty things that go wrong.

Heroes need to be needed.

It's just the way that it's done;

And Max is the one, he's the bloke whom we call,

When a bad guy thinks that he's won;

Or when toilets are clogged, or the cat's up a tree,

Or we need a big hand to hold.

You just never know who's a hero, and you'll certainly never be told.

You'll only find out when you need one – then they'll show up – ta-daaa, just like that!! They'll unplug your loo, make the bad person leave and then go and rescue the cat.

And that's our MAX - Twigshire's Ultimate Super Hero !

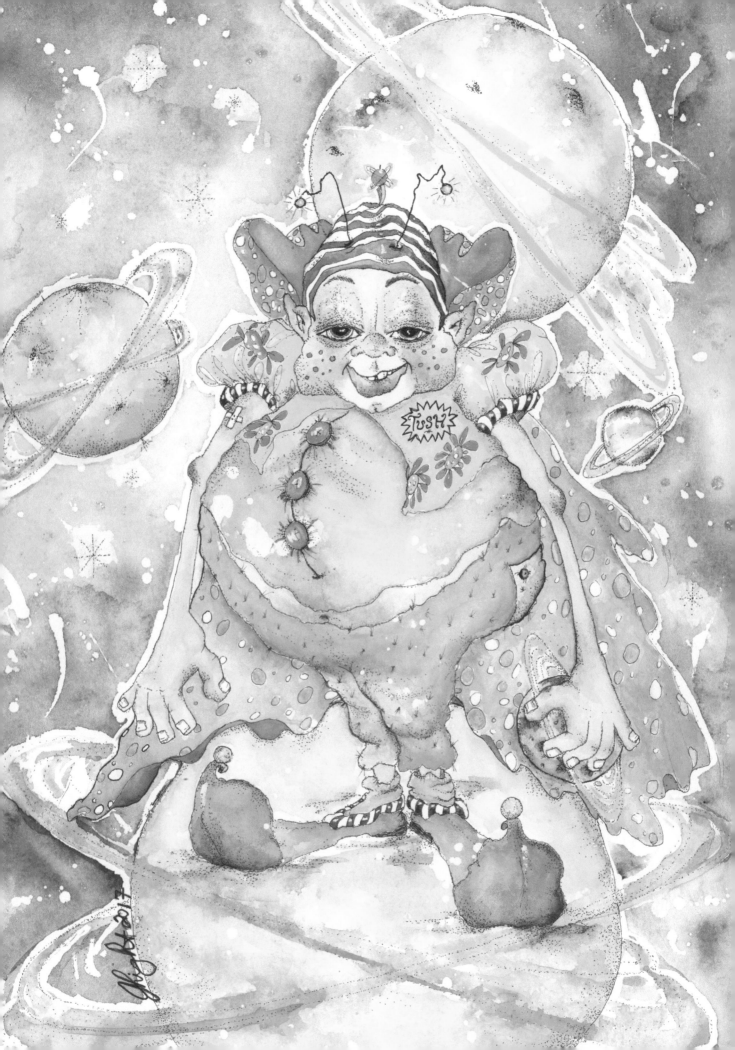

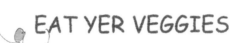

EAT YER VEGGIES

Snails are like people.
(I didn't know that).
They don't dress like people, with shoes or a hat,
But they DO eat their veggies – like we do!

They don't go to school or to work, or ride bikes.
They do not play tennis or take long nature hikes...
BUT... they DO eat their veggies like we do!

Snails understand, so do rabbits and others,
That veggies and fruits make you strong.
(I think that they learned all of this from their mothers,)
Eat yer veggies, you'll never go wrong.

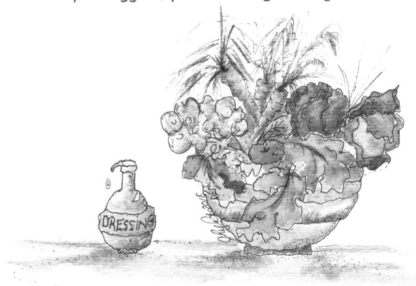

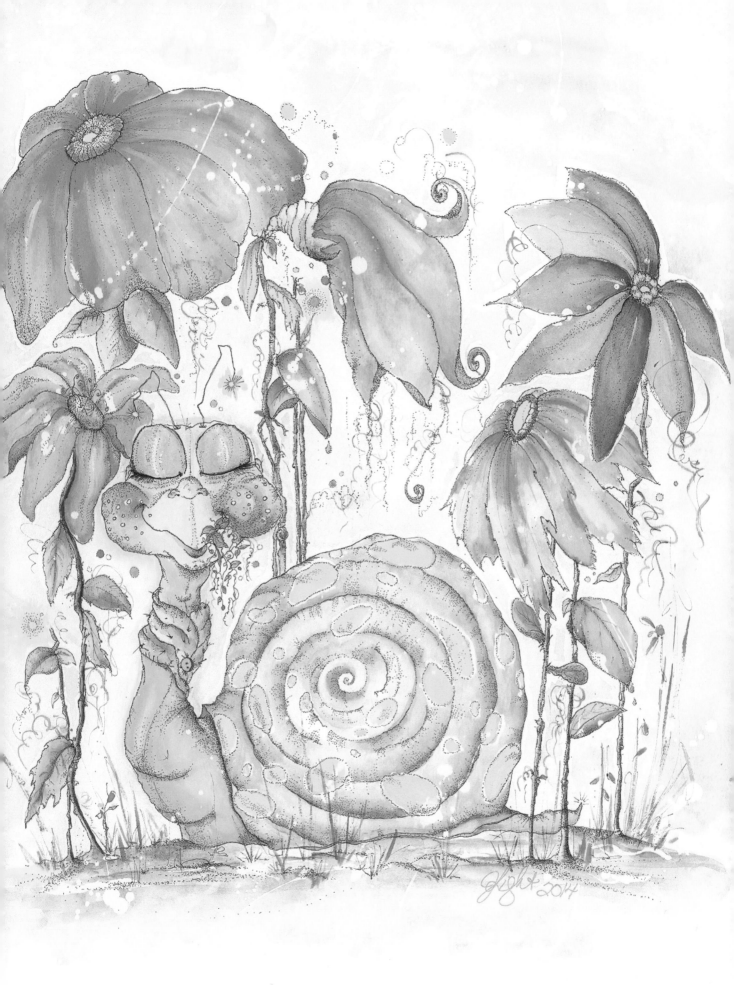

CARMEN

Pondering Pond is home to many of Twigshire's unique population of critters, elves, and odd looking folk. Carmen is one such person.

Carmen used to live in Blue Bottom Bay, but moved over to The Pond when her brother Pedro opened his own Findango Dance studio, with his girlfriend, Saltwater Sue.

It was time for Carmen to find her own place in the community without relying on her big brother so much. She and Pedro could always visit, she thought, being so close by; (Pondering Pond is only about 25 snorks away from Blue Bottom Bay, so not a long swim at all.)

Carmen is thinking that perhaps Twigshire needs another Eatery besides "The Rowdy Toad" in downtown Twigshire or the juice bar, "Smooshed Pulpy and Perfect", so she has decided to do a "Go Fin Me campaign" to raise the needed money for her own cafe.

Here's her ad on her "Go Fin Me" page: See what you think...we wish her the best.

"Carmen's Cafe Salsa"

My name is Carmen, I am Spanish, I like salsa on my Danish.
I like salsa, hot tamales, all that's spicy.
Hot red peppers put on ice cream is delicious
(though it's dicey)
If you've never known, it's quite a tasty dream!
If you try it and you like it, come on back and bring your pals,
See how new tastes tend to add spice to your life!
If you want a change of menu, then come out to my new venue,
Bring your husband, sons and daughters and your wife.

GOAL : $50,000 clams by the summer
RAISED SO FAR: $4.75 clams
Aye Carrrrumba! Good Luck Carmen!

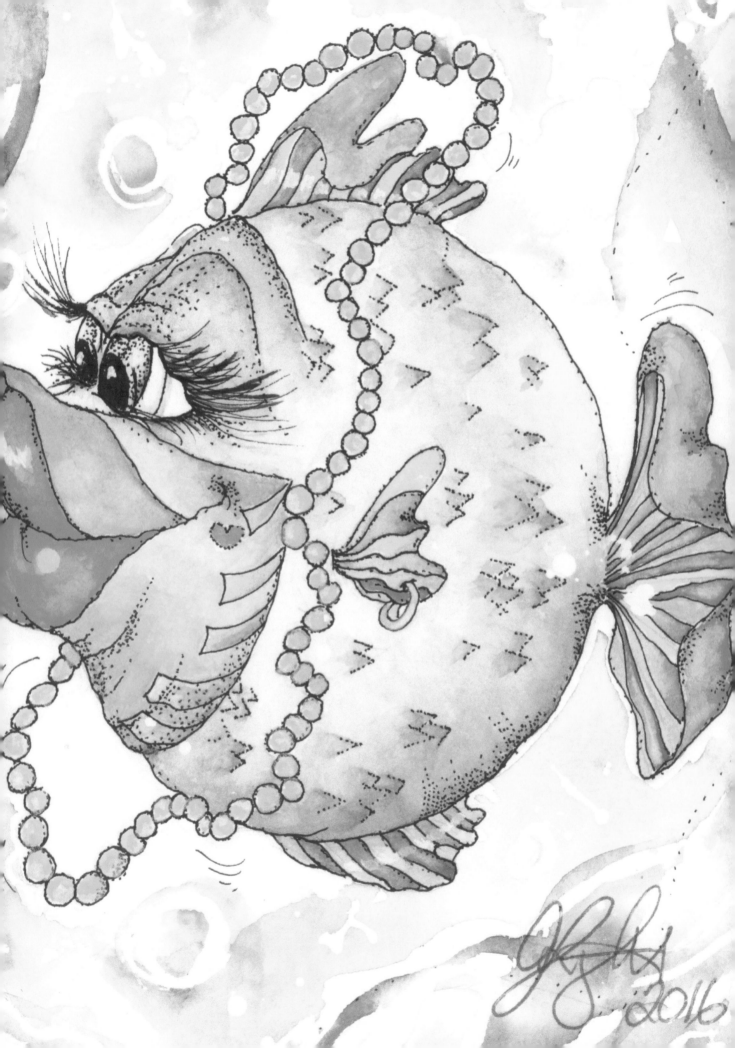

AWWW, DIDDUMS

I see that flu bug next to you, and you both look rather icky.

It seems he entered Twigshire and now you both are sickly.

These sorry little germ bugs tend to fly right in ones' face,

(I don't know how they do that, they're not welcome in MY place).

But somehow they get in there when we're doing something fun,

They bite us as they fly past and then the deed is done.

We start to feel all woozy, blow our nosies, need our mum,

Who tucks our sheets around us, bringing hot soup for our tum.

(And she's the only one who can get away with talking to us like this:)

"Awwwwww diddums.

Diddums get a nasty bug that put you in your bed?

Diddums get a stuffed up nose with an achy throat and head?

Here, I'll make you comfy-bumfy, fluff your blankie, rub your toes

And sooner than TwigWinkle you'll be fine with no more woes.

Diddums?"

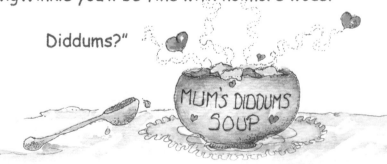

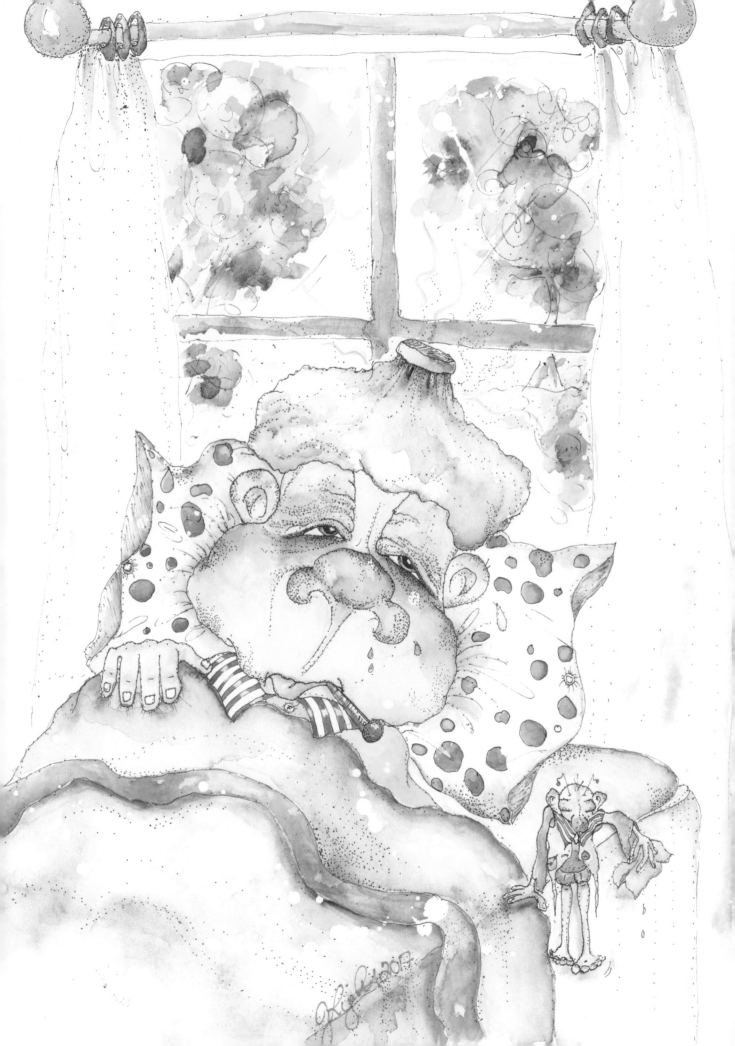

BALANCE

Out past Pondering Pond, beyond the Everything Evergreen Woods, there is a place where many have traveled to meet a bloke who has helped a lot of people over time.

His name is Mushy-San.

He lives on a gigantically fabulous mushroom, named Wally, and they have been residing together for a very long time. It's Mushy-San's job to help sort out those who have forgotten how to be happy; how to make colors out of berries, how to bake a sunflower and acorn pie, and how to spell Snooderblundergandersplotch without looking. Things like that. He helps everyone in Twigshire find their Balance. This is what people say about him:

"When life gets rocky or just too noisy, when people
Forget what they're taught,
It's nice to be happy, of course we all know that, yes
Peace and joy is always what's sought.
Sometimes we wander outside of Ol' twigshire, getting
Tossled and jostled about.
So that's when we need to find Mushy-San,
Go on call him, just give him a shout.
He talks to Miss Moon, holds the Sun in his hand,
He's really so kind, smart and KNOWS.
Just show up, clear your throat, say hello, state your name
And Sir Mushy will banish your woes.
How on earth does he do it? - make us feel good again,
When before we were sluggish, so sad?
He knows that a frown is a smile upside down,
That there's really no feeling that's "bad".

Now go play with some bumbleberry paint or eat a piece of a Bullrush bagel with chocolate sprinkles.

That's Balance!!!

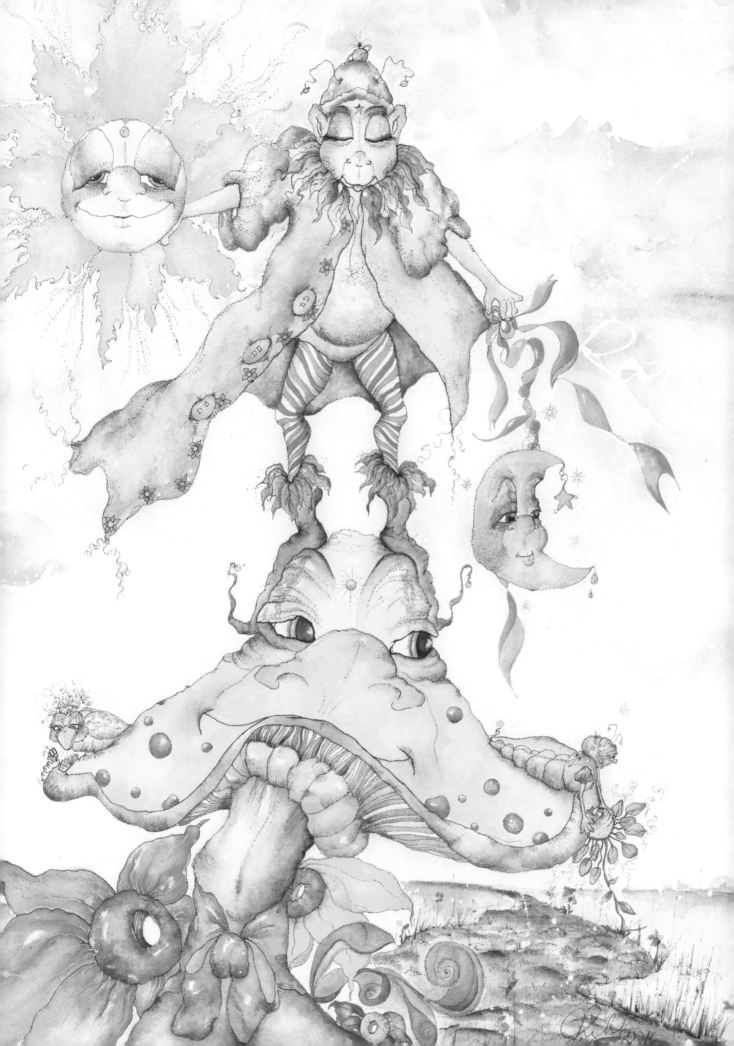

MISSY & MUMFORD MOUSE

Young Missy and Mumford are brother and sis.
When Mumford's a Dad he'll be known as a Mister
While Missy will still be a Miss.

But they'll still be sister and brother!

They do what they're told, go to school, do their chores.
They listen to Mom, do their homework (which bores).
The most fun they have is to tumble and play
In the barn, up the ladder and all through the hay.

Soon they'll be grown, have their own little meeces.
They will tend them and feed them and love them to pieces.
They'll live far apart with their own mousie family

And they'll still be brother and sister!

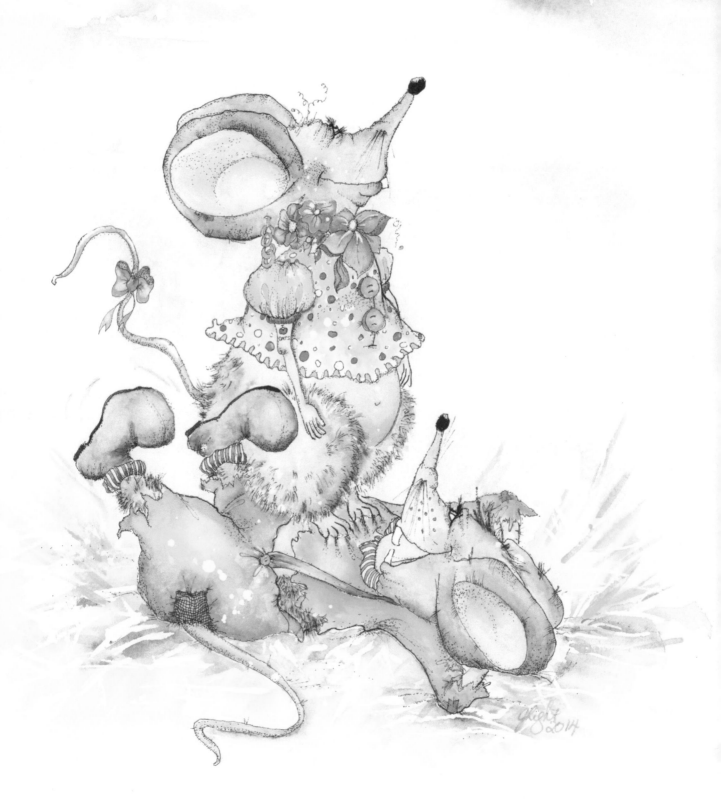

GREGORY GECKO GOES VEGAN

Gregory, was a fellow very set in his ways, combed his hair the same style, always ate the same thing and walked the same path to work. All the time... just all the time. Then one morning, WHAMMO! he had a NEW thought.. which led to a NEW set of ideas.. which pointed to NEW habits.. and suddenly his whole life became bigger, brighter, better and way more FUN!

Listen...

Gregory Gecko now only eats plants.
He's gone strictly Vegan, no more bugs or ants.
He woke up one morning, went out for his walk and whilst strolling along he stopped for a talk.

A lovely wee chap, a bug dare I say, with a plump little tummy, flew into Greg's way. Now, normally Greg would have thought, "Yum, looks like lunch". But this time was different; he'd gotten a hunch.

He said to himself, "I could zap, snap and eat, OR perhaps get to know him, now there'd be a treat"
So Gregory told the chub bug stories grand, of his travels and wishes, that he'd played in a band.

And before you could say "it's time for some pie", the bug said "good evening, I'll just say g'bye.
Perhaps we can meet up tomorrow same place?"
then he flittered his wings and kissed Gregory's face.

Gregory Gecko felt warm, tingly, good.
He realized then that he'd not thought of food.
"A bug is a person, not lunch, mince or stew, but someone to talk to, like me, or like you."
So he ambled along enjoying this state, and picked berries and rhubarb to put on his plate.

Now he's happier, (thinner), his skin has cleared too.
It's amazing indeed what an idea can do.

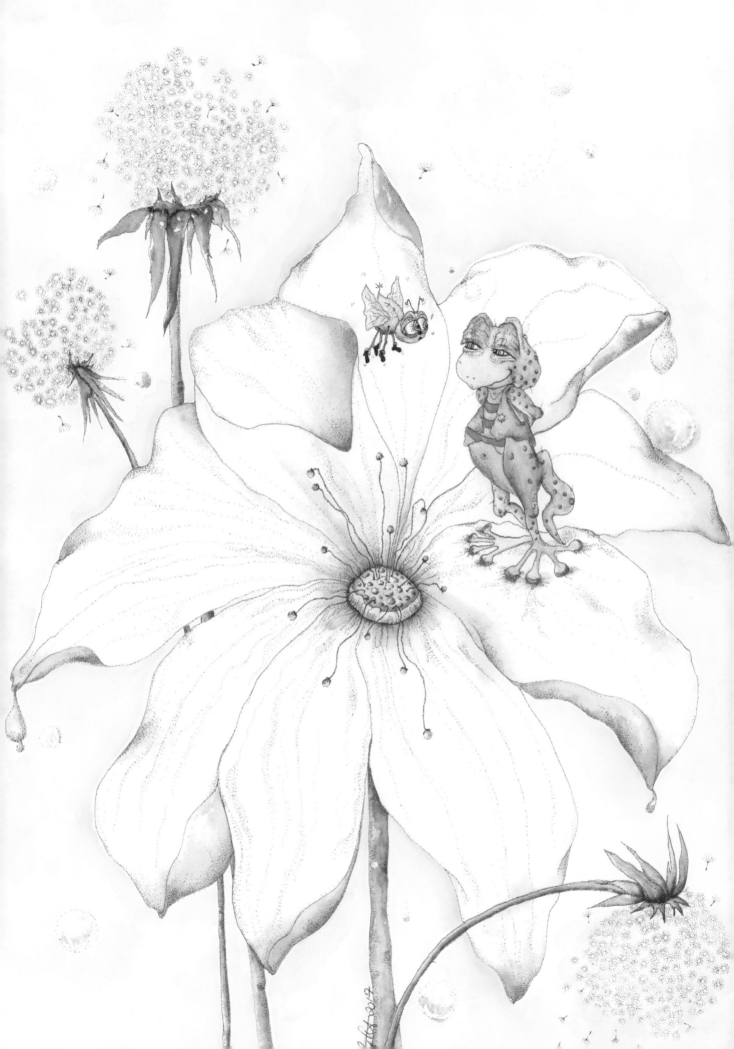

POOF!

I was at my art table one day...sitting in front of a big blank piece of paper, not knowing who or what to draw.

I had a pencil in my hand, but no idea in my mind.
Before I knew it, something happened and gradually my hand was moving, the pencil was drawing, the ink was inking and the paint was painting.

Then, POOF!!! Look who showed up!

"I was nowhere, now I'm here upon your paper...feels like silk.."

"Before I showed up painted I was elsewhere on a caper, flitting here And there with others of my ilk.!"

"You've captured me and gladly will I sit here eons on.

I'll be here when summer's over, when the leaves are dropped and gone.

I'll be here when winter snowfall covers sleeping buds below.

I'll be here because you "caught me" as I flew within the Flow.

Please enjoy me, make a wish, ask me questions anytime.

You went silent and you caught me, now I'm yours and you are mine."

POOF!

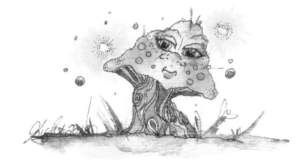

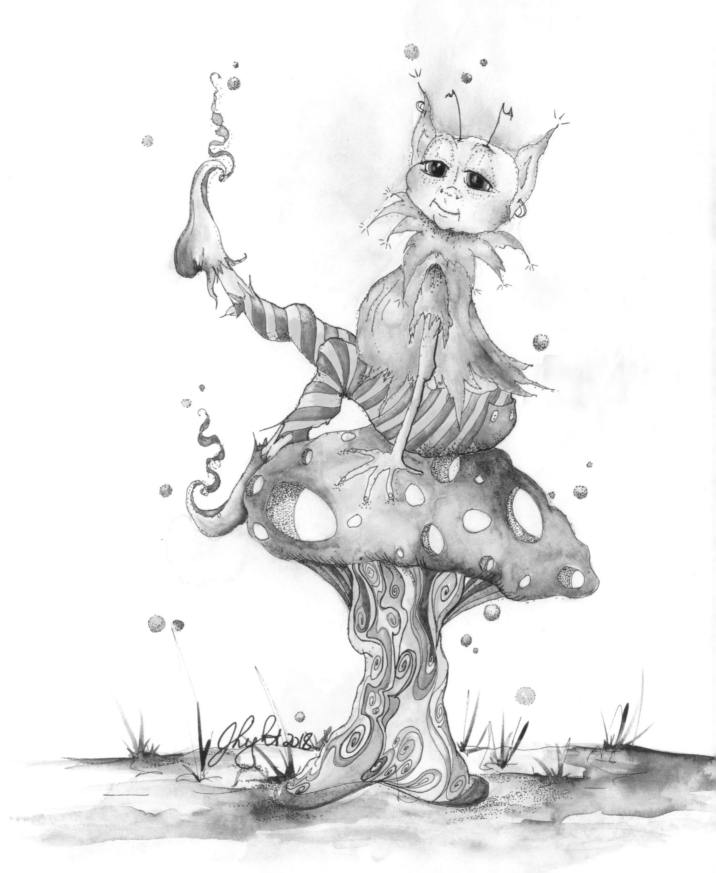

"MEL"

Here's a wee ditty
About an odd kitty,
Everyone knows him as "Mel".

His fur is all raggelly,
His one tooth is snaggelly,
He won't shower so does tend to smell.

He's quite fond of flowers,
Spending hours and hours
Sniffing blooms in his green spotty tie.

He is charming, polite,
He won't scratch or bite,
He is honest and won't ever lie.

So when walking about,
If you see them both out,
They are real and no, not a dream.

The Hat Bird's his pal,
(He's a guy, not a gal)
And they've been friends forever it seems.

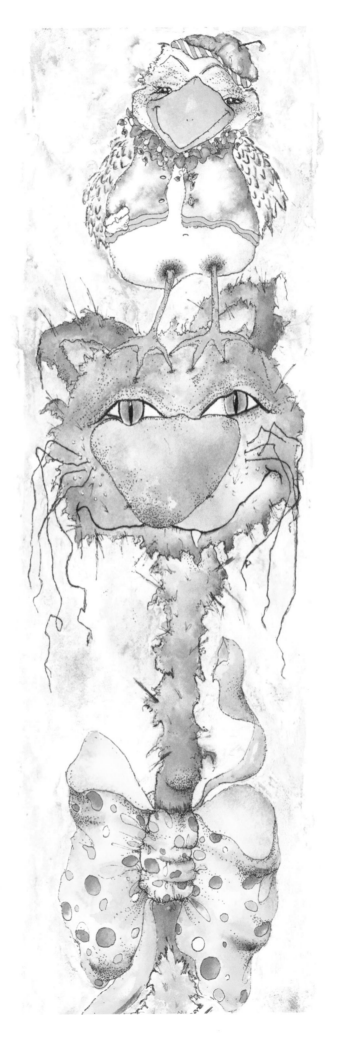

DATE NIGHT

ROMANTIC VERSION:

Sweet Freddy Froggy so loved his mermaid,
He wished he could shower her with diamonds and jade.
Miss Mermaid, however, on a bright night in June, told her sweet frog
that he'd given the moon.
"Just look all about you", she smiled at her love,
"We have star-shine for diamonds in the skies up above."
Diamonds and jade or silks can be taken,
True love though, my dear, is never forsaken."

PRAGMATIC VERSION:

Freddy the Frog and his mermaid girlfriend,
Went out on a date on the pond round the bend.
This was the evening he'd pop the big question!
"Does eating big fireflies give your tum indigestion?"
"How thoughtful" she said, " that you'd think of my tastes.
I don't care for fireflies, they'd just go to waste."

So they sipped sparkling pond water and sighed at each other,
Thus saving a firefly... or maybe his brother.

BRIBBIT!

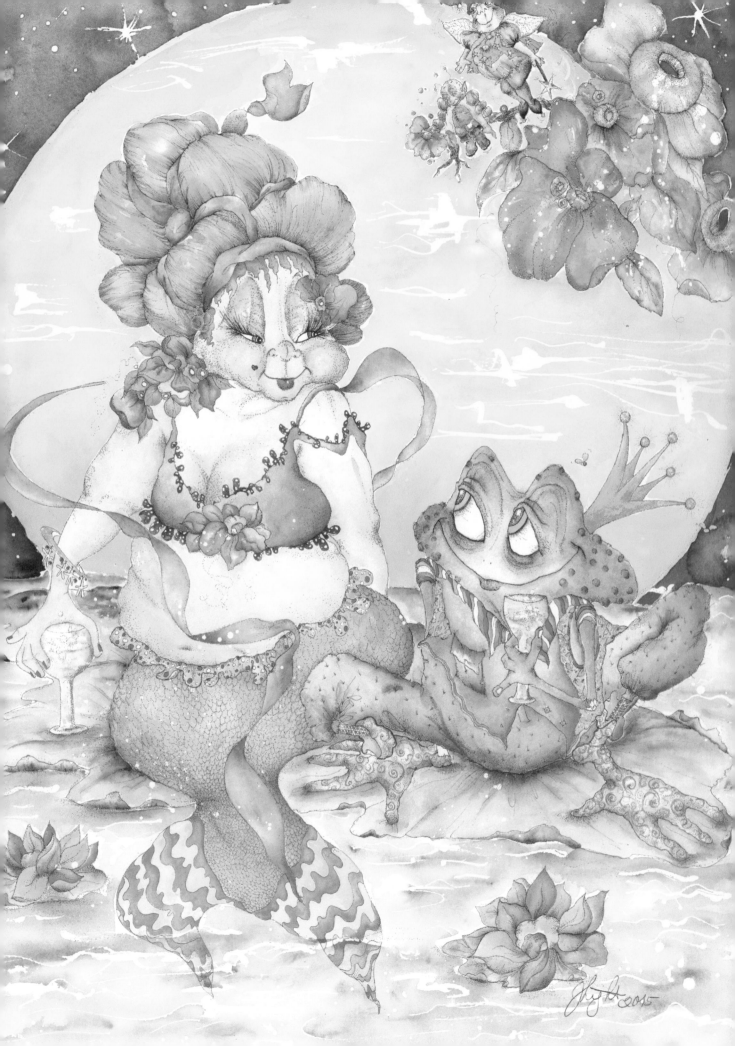

BIXTROM, THE BUMBLER BEE

Once upon a time, in the hugest flower garden ever,
Where the blooms were grand and blossoming in
Every kind of weather...

Buzzed a bee.

The Queen had named him "Bixtrom" for some reason, who knows why?
Perhaps she'd seen some special glint in that young bumbler's eye.
Whatever the reason, Bixstrom wore his tag in shame.
He was the only buzzing hive chap carrying a name.

No other Bumbling Bumbler Bee was labeled John Or Sue.
No...every single one of them was numbered...1 or 2...
Or maybe three or twenty, or fifty nine or more.
He felt left out, so different, which made his feelers sore.

One hot and muggy summer day, with Bixtrom's pollen haul,
He heard a little voice that said, "Hi, Bix, how do? I'm Paul"
Another Bumbler with a NAME? Not one or two or seven?
Bixtrom almost dropped his bucket, had he gone to heaven?

Bix and Paul became best friends, buddies through and through.
It's not much fun feeling all alone, but it's wonderful when there's two.

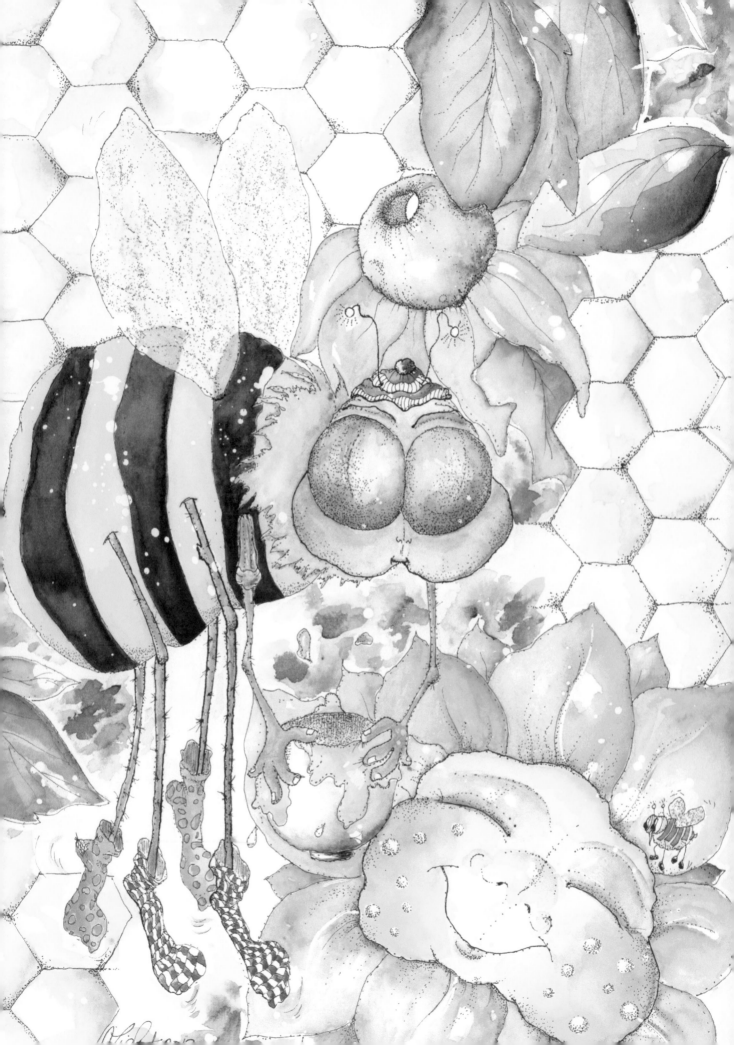

TAKE A BOW

You're Amazing,

You're a Wonder,

You're Terrific,

Take a bow!

You are Perfect,

Simply Wondrous,

Humble, Kind and Caring – Wow!

It isn't about money, big awards and fancy things.

Or whom you know or where you've been,

Just how your big heart sings.

You sure could teach the rest of us

Just how the Heck it's done.

This crazy job of Living life, with love and Grace.

You've WON!

Take a Bow!

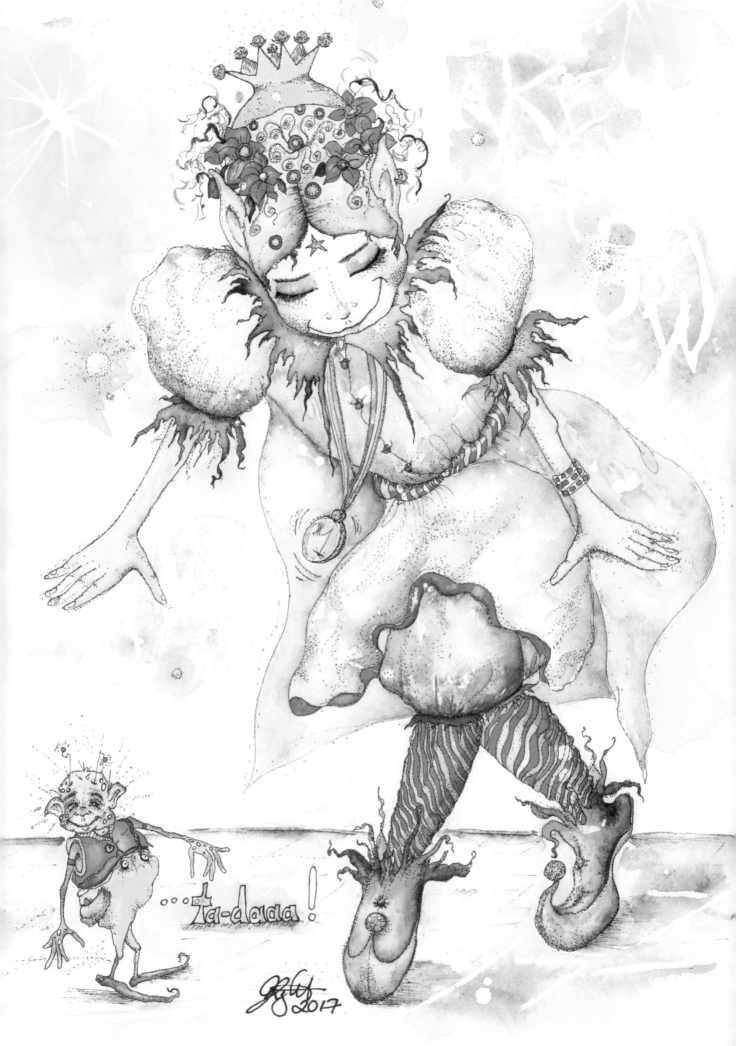

...ta-daaa!

Comments from the Twigshire Twitterings weekly newspaper!

Beautifully written, masterfully illustrated, Judi Light is a one of kind gifted artist and author who brings laughter and joy to everyone. Written for both adults and children, Judi Light's whimsical characters will teach many life lessons while entertaining and encouraging the spirit and soul of each reader. Thank you Judi for your very creative gifts to us all.
— Joan Nestor

Colorful characters are brought to life by a wonderfully imaginative artist. Delightful and wonderful prose to share with family and friends. We all need a touch of whimsy in our lives. These books always add a smile to my day. Read on and be inspired!
— Terri Breaks, Canada

With the majical alchemy of pen and color along with her compassionate mind and heart, Judi draws me into a world of pure Goodness on every page of her Twigshire tales. In these truly mystical worlds she gives dignity and even a place of honor to the differences of all beings in creation.
— Terrence Joyce, Artist, writer, lecturer and principal of Terrencejoycegallery.com

Cameron (4.5) reads to baby brother Finn (4 months) This is one of Cameron's favorite books! He loves all the characters & the fact that they're all so different. We often read Judi's book first thing in the morning to set the mood for the day!
— Jen Bromley, Connecticut

Dear Judi,
I love all of your beautiful and colorful books. They are always so positive. I love your choice of Art and I give your books ☆☆☆☆☆ stars and 1,000,000 thumbs up! Love, Maddi

The characters of Twigshire made me smile and dream during my pregnancy. today they are part of Monika's bedtime routine. In the detailed and whimsical pictures created by Judy, we recognize ourselves; her words will guide us as parents. The world of Twigshire is full of love, her characters make this world a happier place.
—Daniela, Scott and Monika Myers

Parents Cara and Jason enjoy bedtime reading to Michaela (5) and brother Finn (3). "We love the upbeat and positive messages the stories give them and they often ask questions which we're happy to answer."

I am in awe of your imagination and artistry, and the pure ebullience that shines through each one. I'll be traveling soon to see my very good friend and I've been looking for just the right gift to bring along with me. That "something" had to be part whimsy, part loving, part thoughtful, part sentimental, part laughter, and (oh by the way), amazing to look at. So, my search is over, a copy of Twigshire will be presented upon my arrival.
—Joyce Scott

I was going about my day, a gray day without it seemed from within, when suddenly a shower of color gave me smile. I had stumbled into Twigshire, a place of magic and merriment. My good luck continued as the first citizen to greet me was Mz. Emelda Flapjacket, who took me on a Field Trip. Eyes awash and senses ashine, I followed her and saw many fine places from Pondering Pond to Blue Bottom Bay, a fabulous vacation spot you can read about in the Twigshire Twitterer. Too soon though, it was time togo. I'm coming back with my soul mate, Sari, next time and just like Lulu McDruthers and her BFF Spot, we'll find a fabulous place to sit and talk.
—Mike Masin, Artist

The Artist/Author

JUDI LIGHT is British born, Canadian raised and, after living abroad and in many cities across the U.S., now resides in Venice, Florida. She has been a caricature artist for most of her life, creating black and white whimsy pieces which have been published as cards, coloring books and for private collections. Many of her current pieces are now in the Permanent Collection of the well known Museum of Art & Whimsy in Sarasota, Fl, where in 2017-18 she was chosen for the Museums first seasonal featured artist showing.

In 2011, she had revisited her black and white Wee Folk (who were patiently awaiting her return), with the added bonus of discovering the total joy of watercolors. And that's when the Magic happened! Whimsical paintings and stories began arriving, along with the wonderful village called Twigshire!

She is a self taught artist who uses her creativity, realism, passion and artistry to make whimsical, touching, humorous paintings that uplift and lighten the soul. As they are packed with detail, take your time enjoying each piece. Children often spy out things missed by their parents!

The reviews of her work have been glowing and they have often made comparisons with the works of Beatrix Potter, Dr. Seuss and other noted whimsy artists.

Judi says that "...the purpose of my art and words is to ramp up the Happiness Factor, possibly encourage some insight, perhaps impart a life lesson... and ALWAYS to leave you smiling."

You may write to Judi at: Judi@LightTouchArt.com Her website is: http://LightTouchArt.com ENJOY